IMMORTAL INK

PLUME

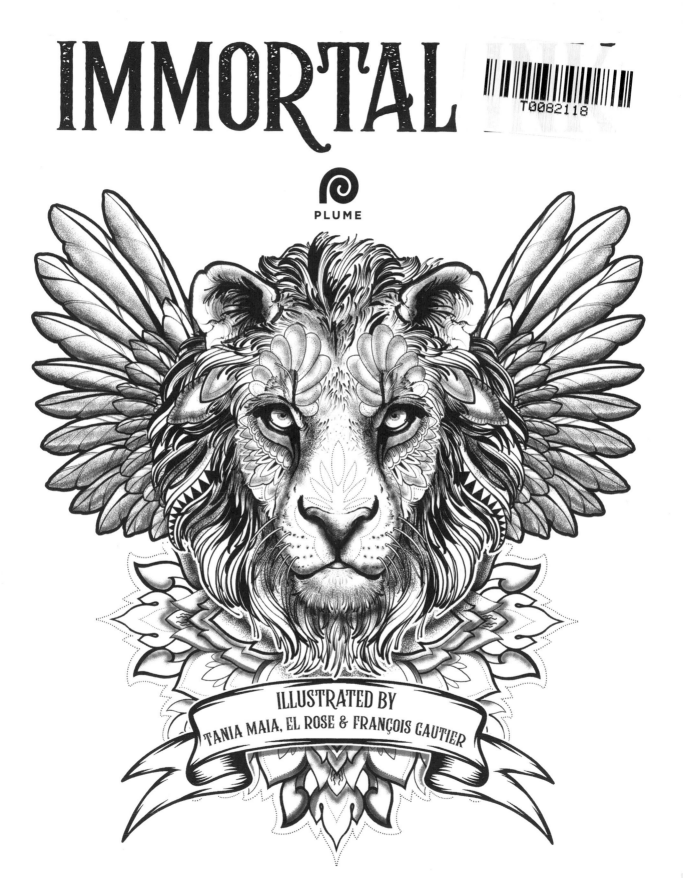

ILLUSTRATED BY

TANIA MAIA, EL ROSE & FRANÇOIS GAUTIER

ILLUSTRATED BY:

TANIA MAIA

EL ROSE

FRANÇOIS GAUTIER

COLORED BY:

..

PLUME

An imprint of Penguin Random House LLC
penguinrandomhouse.com

W www.mombooks.com/lom

f MichaelOMaraBooks

OMaraBooks

lomart.books

LIBRARY OF CONGRESS CATALOGING-IN-PUBLICATION DATA
has been applied for.

ISBN 9780593187340 (paperback)

Printed in the United States of America
1 3 5 7 9 10 8 6 4 2

BOOK DESIGN BY DERRIAN BRADDER

INTRODUCTION

For thousands of years and across many different cultures, the body has been used as a canvas. Body art serves a myriad of purposes—a rite of passage, protection from evil, a symbol of group identity, or simply a personal expression of self.

As a result of this abundant history, a multitude of distinctive tattoo styles have developed, rich in symbolism and meaning. From sailor-inspired Americana to steampunk Victoriana, the tattoo designs in this book reflect some of these different styles and capture the spirit of their origins.

Color and complete 45 awe-inspiring designs, and discover the fascinating meaning behind each one.

AMERICANA

As much a social phenomenon as it is an art movement all of its own, Americana is one of the most well-known and popular tattoo styles. Bold, black outlines are complemented by large blocks of saturated reds, blues, and yellows. The clean lines and simple use of color look deceptively straightforward, but it takes precision and a very steady hand to pull off these graphic designs.

While other tattoo styles may leave the artist room for personal touches and interpretation, classic Americana should be instantly recognizable in both line style and subject matter.

Many designs have a nautical theme. The American Revolution, in the second half of the eighteenth century, is often seen as the starting point of a tradition of soldiers and sailors getting tattooed in this style.

The designs are seen partly as a symbol and reminder of home, but also act as identification if their lives were lost in war. The journeys taken by these men spread the style far and wide, and helped to create this unified aesthetic that became known as "Americana."

SHIP Spending months, or even years, at sea on a ship made the vessel incredibly important to a sailor. Not only was it home, but it also symbolized direction and a way of life. The meaning behind a ship tattoo varies, but it is often associated with a journey or love of travel. It could also mean someone is navigating the waters of their own life, or wants to demonstrate their free-spirited, adventurous nature.

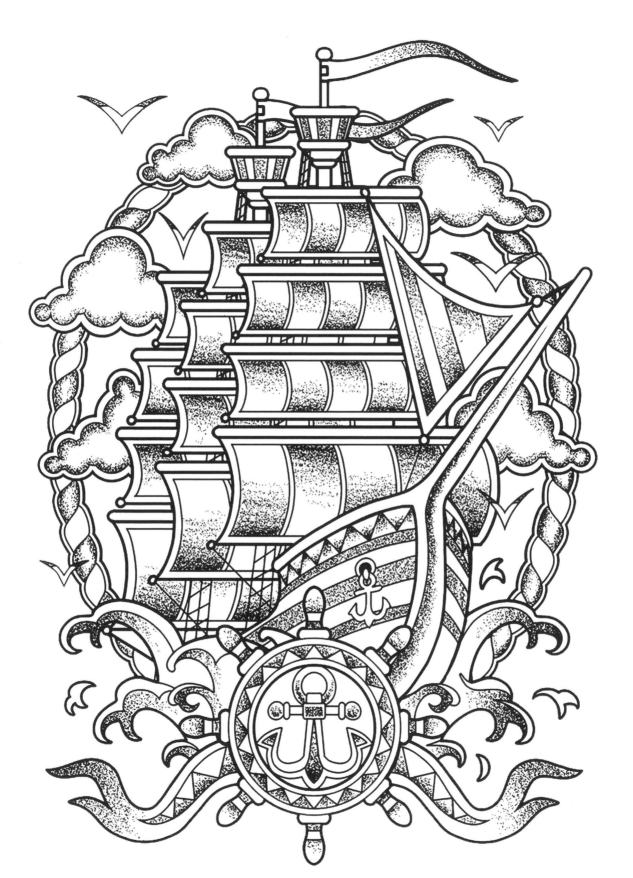

AMERICANA

S T A G Featuring prominently in the mythologies of many different cultures, this majestic "king of the forest" is a popular choice for a tattoo in the Americana style. With antlers pointing skyward, the deer is often seen as a symbol of spiritual superiority and of being close to the heavens. Rendered in the traditional style, with flat colors and bold outlines, the stag is often used to represent strength, serenity, and regeneration. Here, the use of oak leaves and acorns reinforces the themes of solidity and steadfastness.

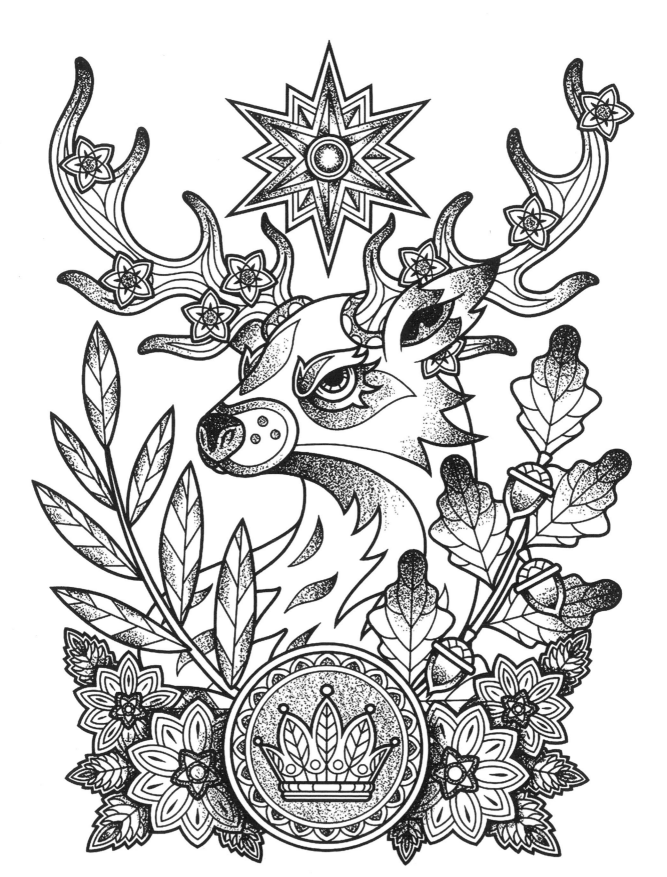

AMERICANA

LIGHTHOUSE Lighthouses are symbols of protection. They guide people to safety and are a hopeful sight to any sailor returning from a long stint at sea. Someone choosing a lighthouse tattoo may be comforted by the reminder that stormy seas don't last forever, and by the idea of a guiding light illuminating life's path.

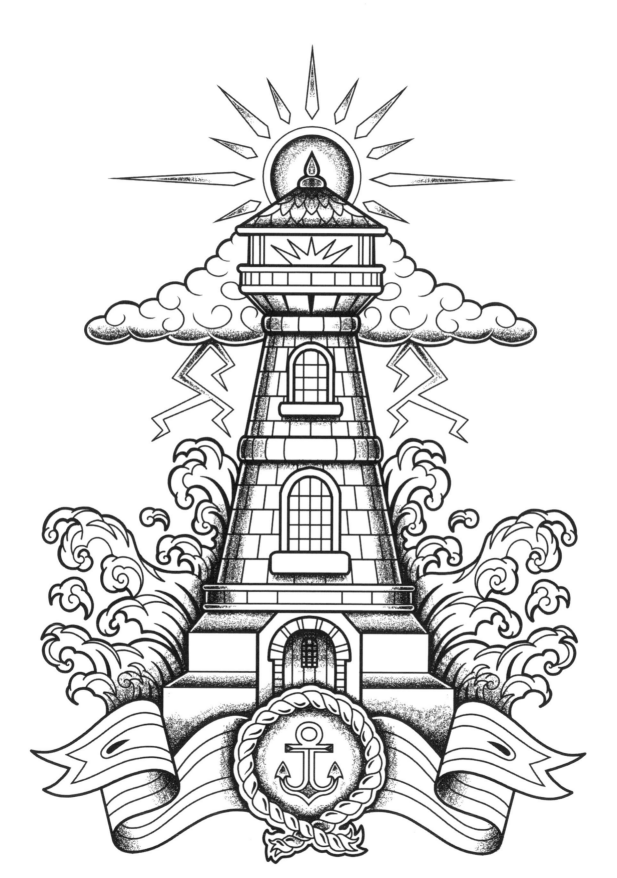

AMERICANA

SWALLOWS A swallow was the traditional symbol for having sailed 5,000 miles. A sailor would often get a swallow tattoo before he set sail, and then another when he returned, hence they are often featured in pairs. Just as swallows return to the same place each year, a swallow tattoo can be used romantically as a sign of faithfulness and a promise to return home.

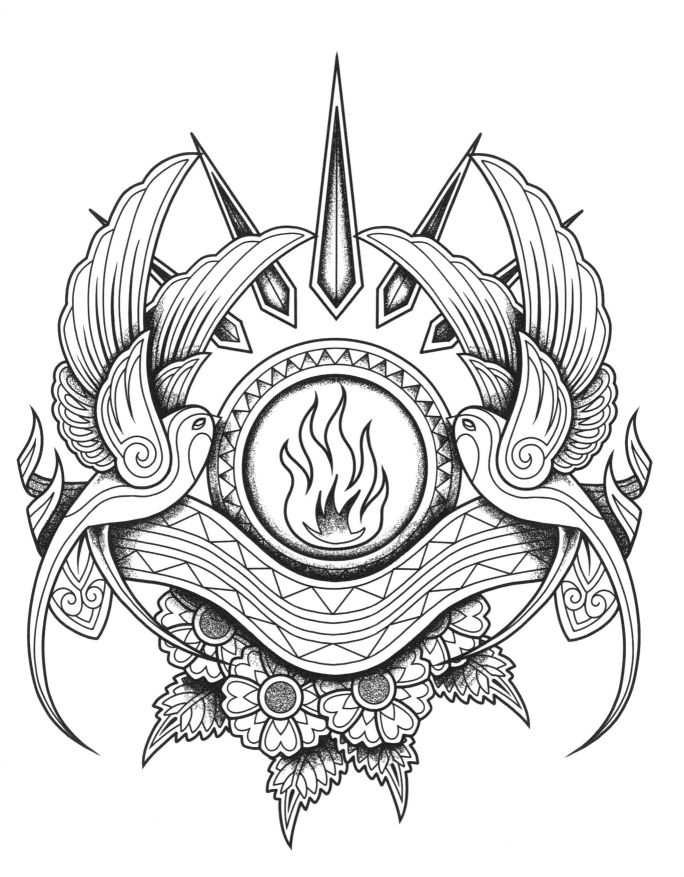

AMERICANA

DIVING GIRL Similar to pinup girls of 1920's pop culture, which can be seen as a celebration of the female form, the diving girl can be interpreted as a symbol of femininity and female power. Sticking with the retro Americana look, this example is dressed in a modest swimsuit, her tongue-in-cheek salute a nod to the military origins of this sailor-style design.

MERMAID The mermaid has historically been an important figure in legends and folklore, often associated with sailors and open water. In many myths, mermaids lure sailors to watery deaths with their beautiful singing in order to steal their treasures. As such, it is common for the mermaid to be portrayed as a seductive figure. Here, she is accessorized with seashell jewelry, seashells traditionally being a symbol of feminine power and good fortune.

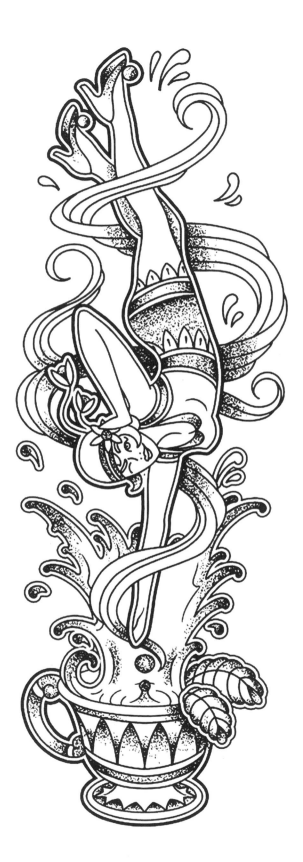
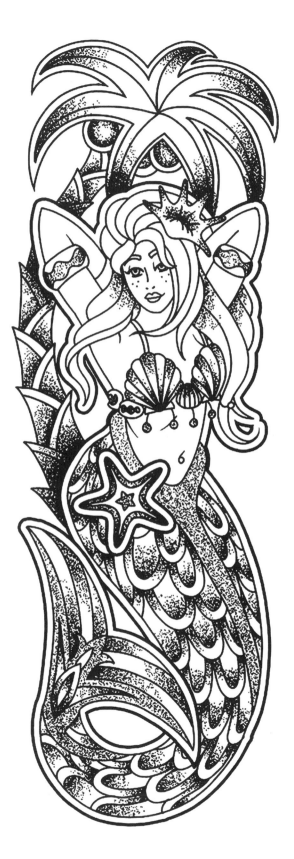

AMERICANA

FLYING HEART

Hearts are a classic choice and a way of keeping loved ones close. They can be personalized with names, and the addition of wings can symbolize a free-spirited, adventurous nature.

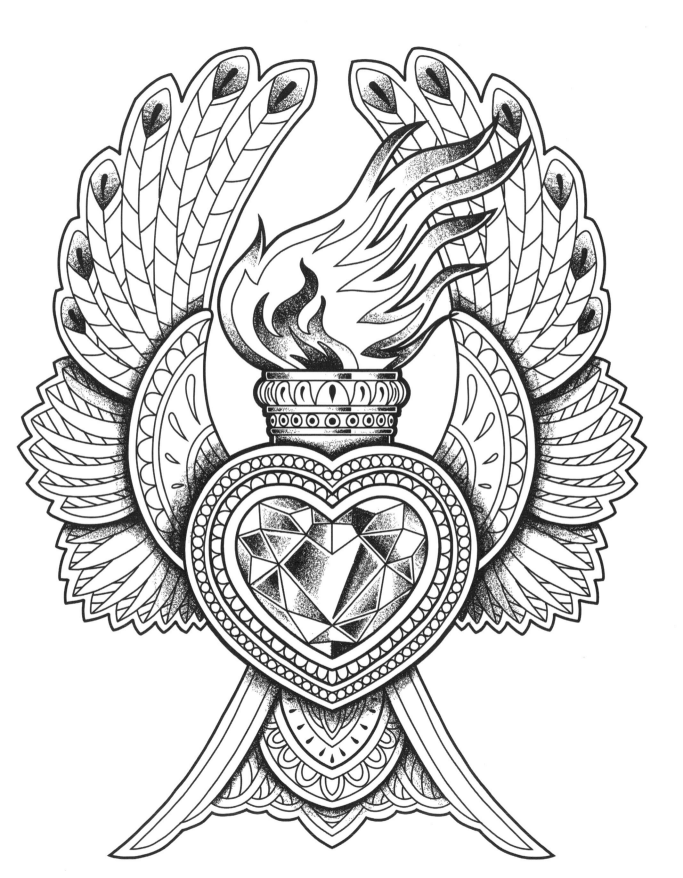

AMERICANA

LANTERN A versatile option
that can be rendered in many different
and highly decorative forms, the lantern
symbolizes a quest for knowledge and
finding a true path in life. A strong
symbol of positivity, it can also be used
as a literal depiction of the "light in the
dark." The motivational message is here
reinforced by the inclusion of death's-
head hawkmoths, which represent
faith in the future and a determination
to seek out the lightness in life.

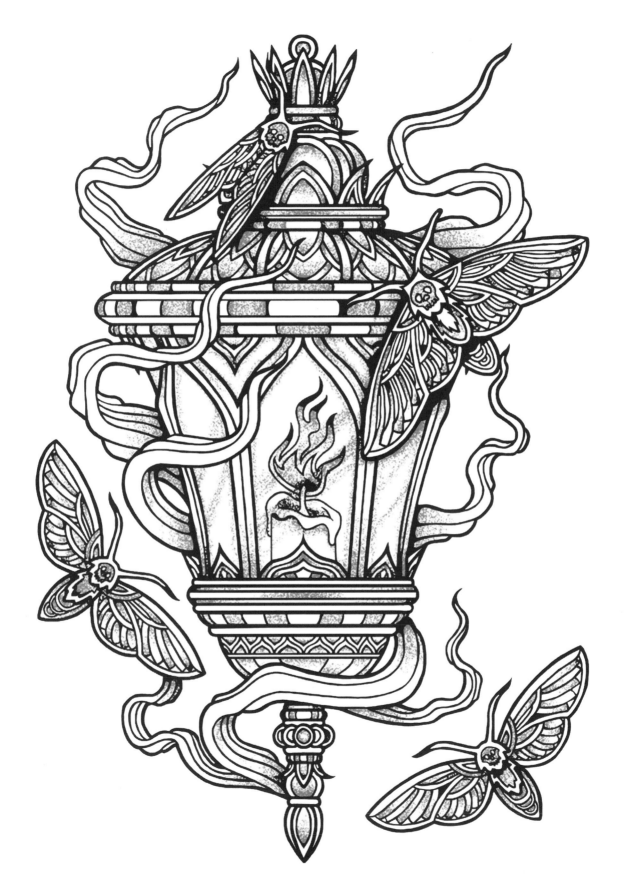

AMERICANA

D A G G E R At first glance, this weapon may seem like a symbol of brutality, and indeed it can be used as a mark of betrayal and loss. However, a dagger design can also represent a person's willingness to fight for what's right, commemorating an act of bravery or sacrifice. The appearance of the sun motif reinforces the idea of this as a positive design, suggesting that the recipient is looking ahead to brighter times.

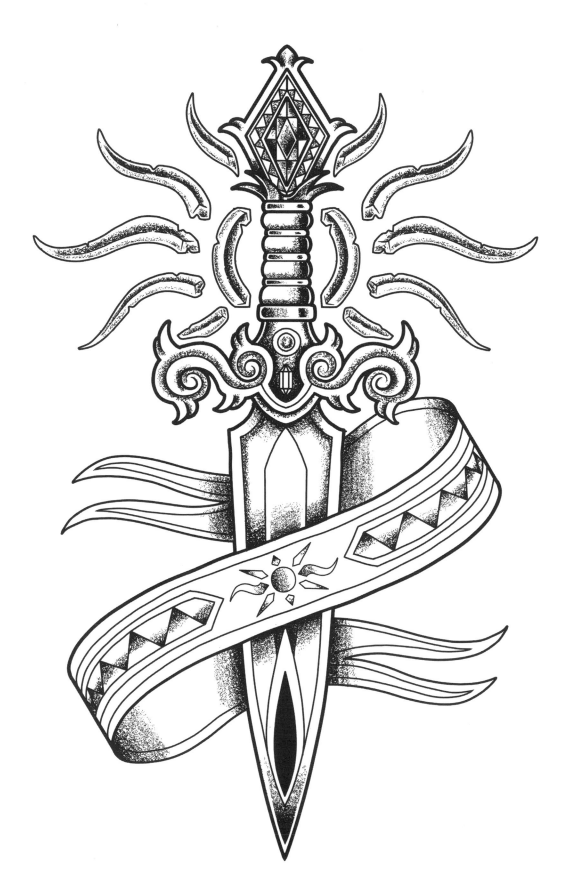

ILLUSTRATIVE

An illustrative tattoo can be anything you might see drawn on paper or in a book—if it looks like it could be on a page instead of skin, it's probably illustrative. Inspired by a whole range of cultures and concepts, there are as many types of illustrative tattoos as there are art styles, making it one of the most versatile types of tattoo.

Many illustrative tattoos are completed in black ink. In these designs, the tattoo artist might make use of shading, cross-hatching, and stippling to add to the hand-rendered quality. When color is used, it is usually in a muted palette rather than the bold, contrasting shades of more traditional tattoos.

Illustrative tattoos might have a bold, graphic look or a whimsical, fairy-tale quality, but whatever the style, the common features of all illustrative tattoos are a hand-drawn feel and an animated, nonrealistic finish.

SNAKE AND SKULL

Botanicals, animals, and birds are common subjects of the illustrative style. This design has an ethereal quality with delicate linework and uses the juxtaposition of pretty florals with more sinister elements to dramatic effect. This tattoo would be drawn freehand onto the skin rather than using a premade stencil, in order to work with the natural contours of the body.

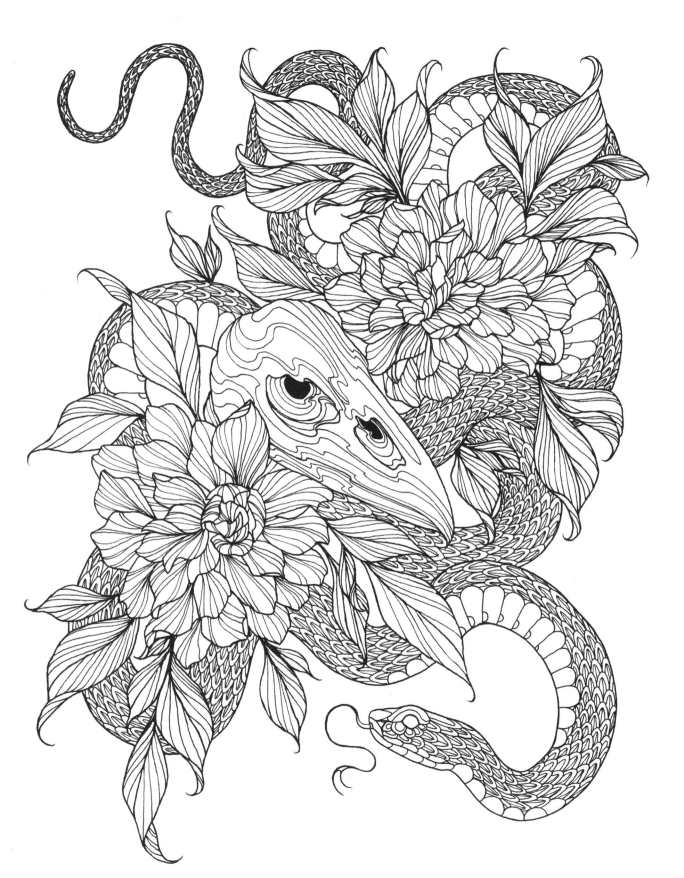

ILLUSTRATIVE

O C T O P U S Squid or octopus
tattoos are often used to symbolize
growth, resilience, and adaptability, all
qualities that these sea creatures possess
in real life. Their ability to change color
means they offer scope for both creative
color combinations—blues, greens, and
oranges being popular choices—as well
as more neutral or grayscale options.

The black background contrasts with
the delicate lines of the octopus's
skin. Its solid shape makes the
feeling of movement provided by the
tentacles all the more effective.

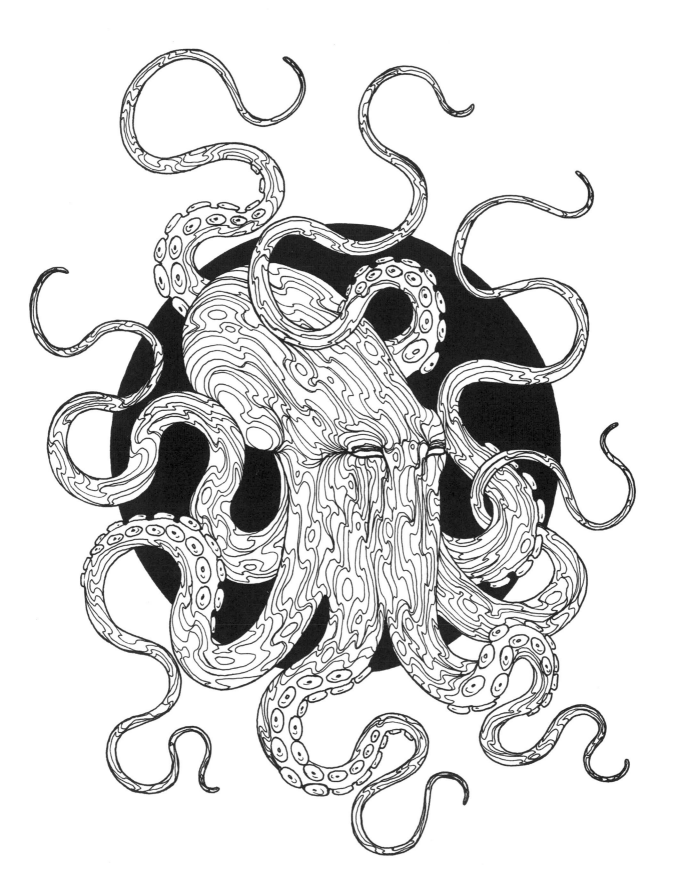

ILLUSTRATIVE

DRAGON Demons, dragons, and other mythical creatures are popular motifs in the illustrative style. These pieces often have the feel of etchings or engravings, and may be heavily influenced by dark arts, alchemy, and other esoteric philosophies.

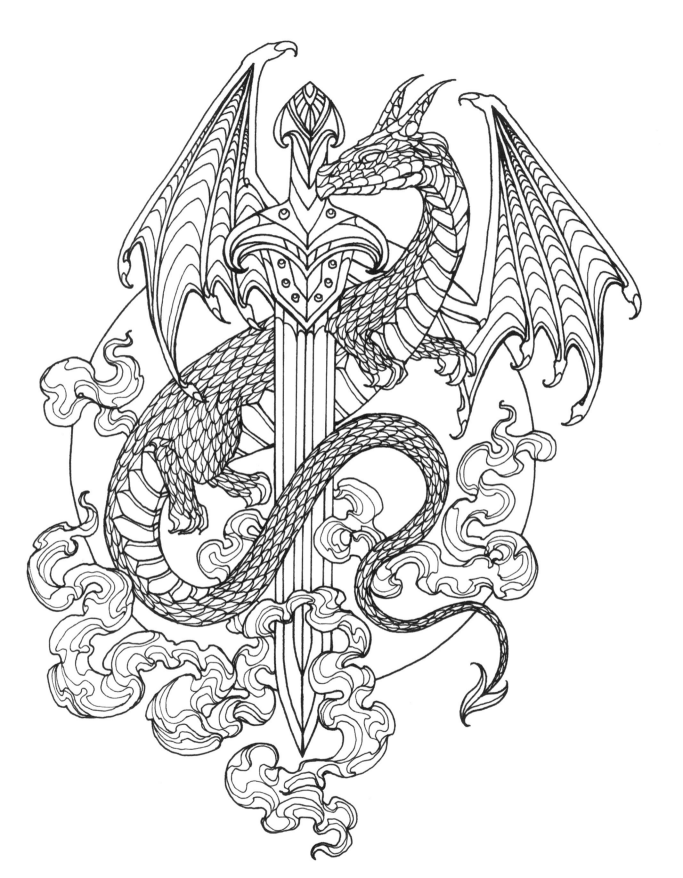

ILLUSTRATIVE

BUTTERFLIES Floral butterfly tattoos symbolize serenity, innocence, and a love of nature. The type of butterfly that features in the design can also have an impact on its meaning; for example, in many cultures, a monarch butterfly represents transformation and moving forward, a spring azure is a symbol of light and life, and a black swallowtail can signify mortality and new beginnings.

The butterflies in this design are perfectly complemented by peonies, which—yet to bloom—are a common symbol of love as well as the beauty and fragility of life.

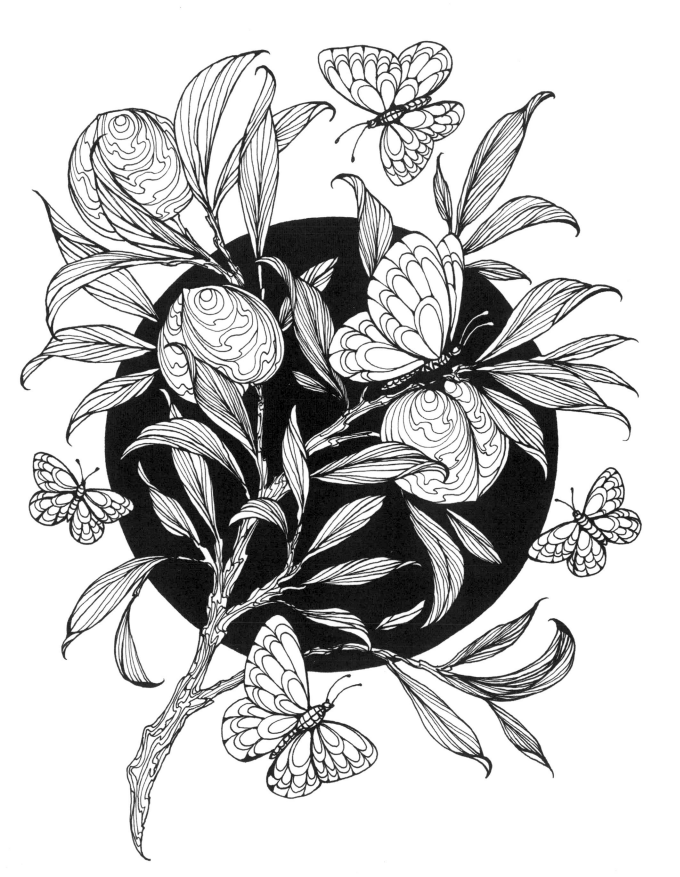

ILLUSTRATIVE

B L A C K B I R D Artists have always been drawn to birds as a way of expressing freedom, both in a spiritual and physical sense. In some cultures, birds represent the connection between heaven and Earth and, as such, are a symbol of eternal life. In this particular design, the blackbird was chosen for its links with mystery and secrecy. It conveys the idea that life unfolds before us with its outcome unknown. The blackberries that surround it are thought to attract wealth and prosperity.

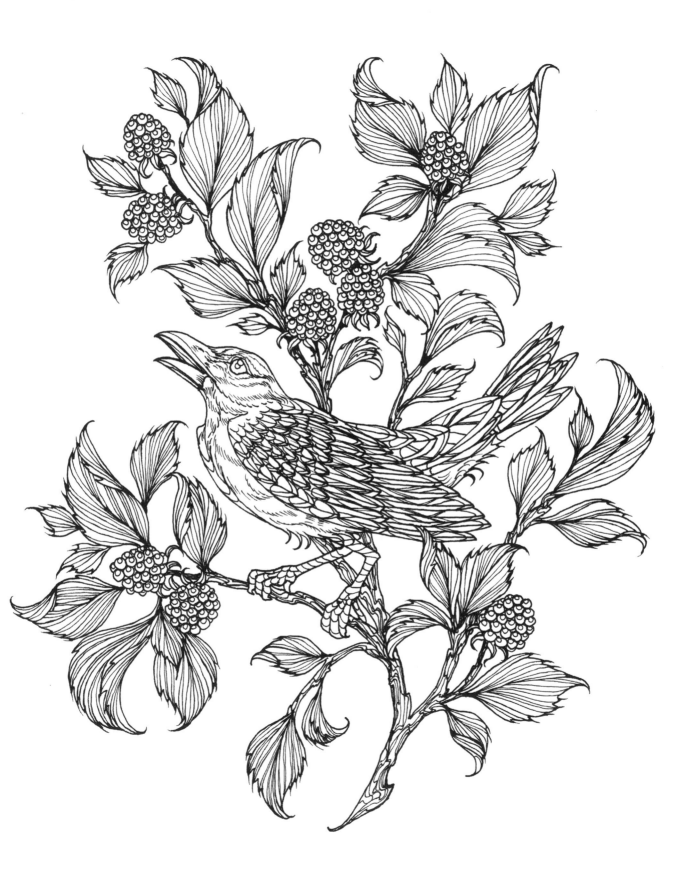

BLACKWORK

Characterized by strong, simple, clean lines and powerful use of negative space, the enduring popularity of blackwork is impossible to ignore. Because blackwork is a broad term, used to mean anything drawn using only black ink, the style can encompass many different genres, such as illustrative, calligraphic, or etching. However, the origins of traditional blackwork lie in ancient tribal tattooing—specifically in the Polynesian style.

Abstract swirls and patterns designed around the contours of the individual's body complement their personality or illustrate their lineage. Many tattoo artists today honor this tradition and work within this style.

Sacred geometry is another popular inspiration for blackwork designs. The idea that perfect geometric structures exist everywhere in the natural world is reflected in intricate, mandala-style tattoos.

Also popular are more modernist, highly graphic designs with simplified shapes and blocks of black ink.

TURTLES The Polynesian style of blackwork tattoo is a highly refined, traditional art. Tongan warriors were tattooed from the waist to the knees with a series of geometric patterns, mostly consisting of repeated triangle motifs, bands, and also areas of solid black. The turtle is an important symbol across all Polynesian cultures, representing health, longevity, and unity.

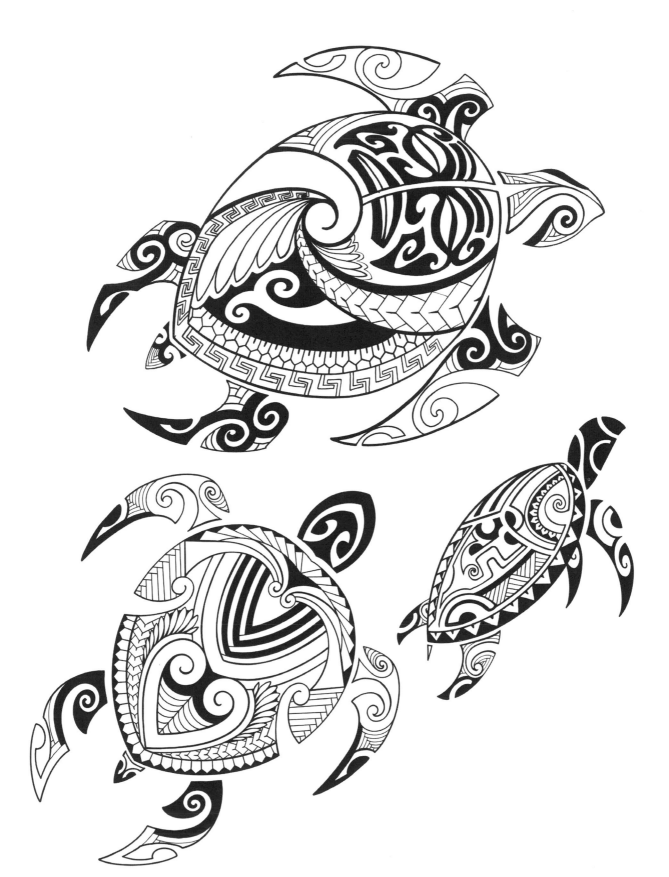

BLACKWORK

INTRICATE LEAF

Taking inspiration from mandala patterns, the floral elements of this nature-inspired design symbolize the translation of nature into perfect geometry, while the swirls and twists represent the trials and tribulations that we all face in everyday life.

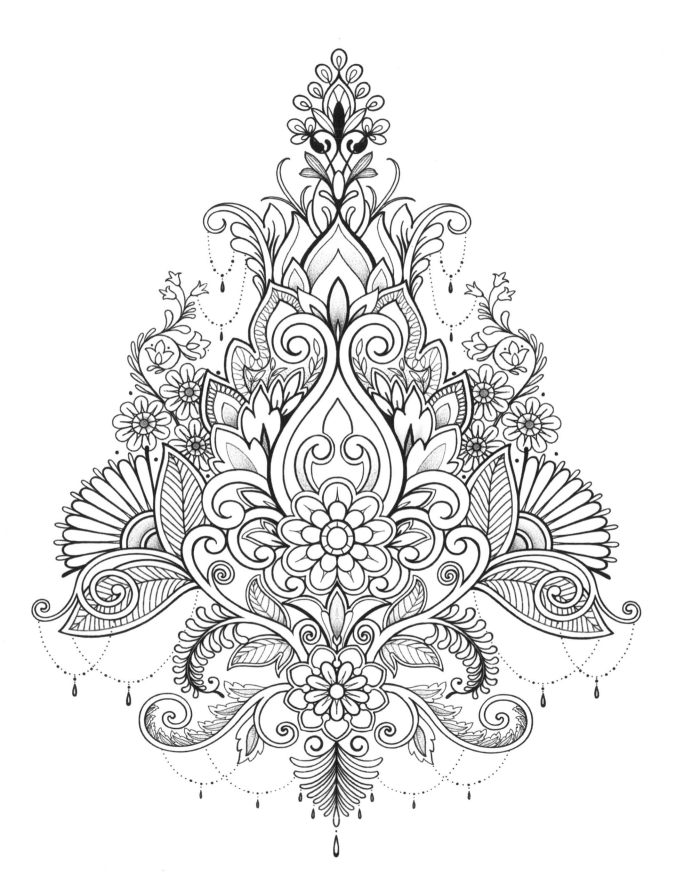

BLACKWORK

LION MANDALA

This design combines the sacred geometry of mandalas with the idea of inspirational animals—animals that reflect a person's personality and whose qualities resonate with the individual. Inspirational animal tattoos have a powerful meaning, as the person will feel a unique kinship with their chosen animal. Lions are often used to represent strength and courage in the face of difficulties. Other popular animal tattoos include elephants, eagles, and owls.

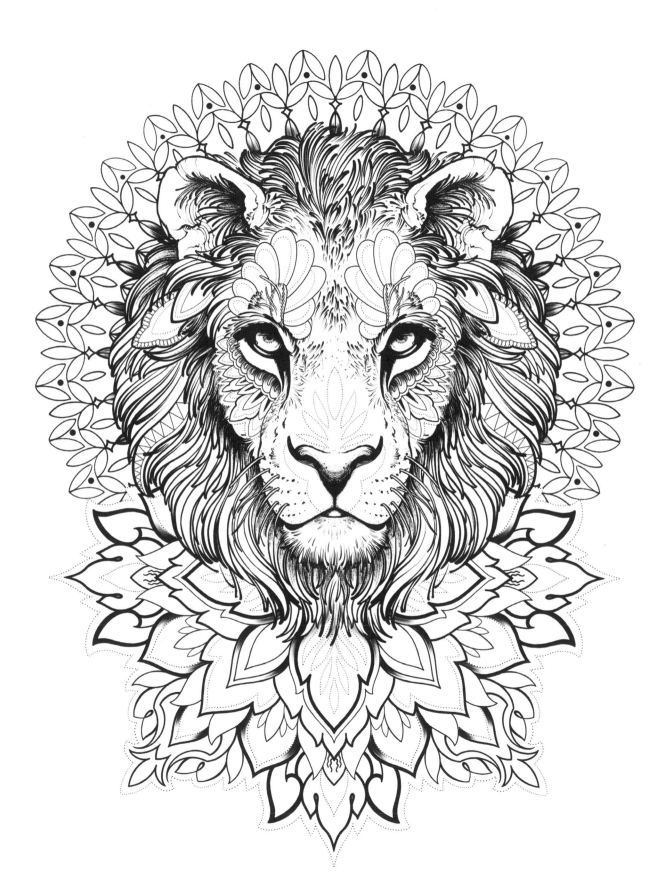

BLACKWORK

BLEEDING HEART

Strong, graphic lines give this bleeding-heart design a bold and striking look. Representing wavering strength and the experience of deep sadness, a bleeding-heart tattoo may be chosen in relation to the death of a loved one, and may remind the bearer of the pain they have suffered and the process of healing. While the wounds may feel fresh, depicted by drips of blood, the bleeding heart is a symbol that nothing, good nor bad, lasts forever.

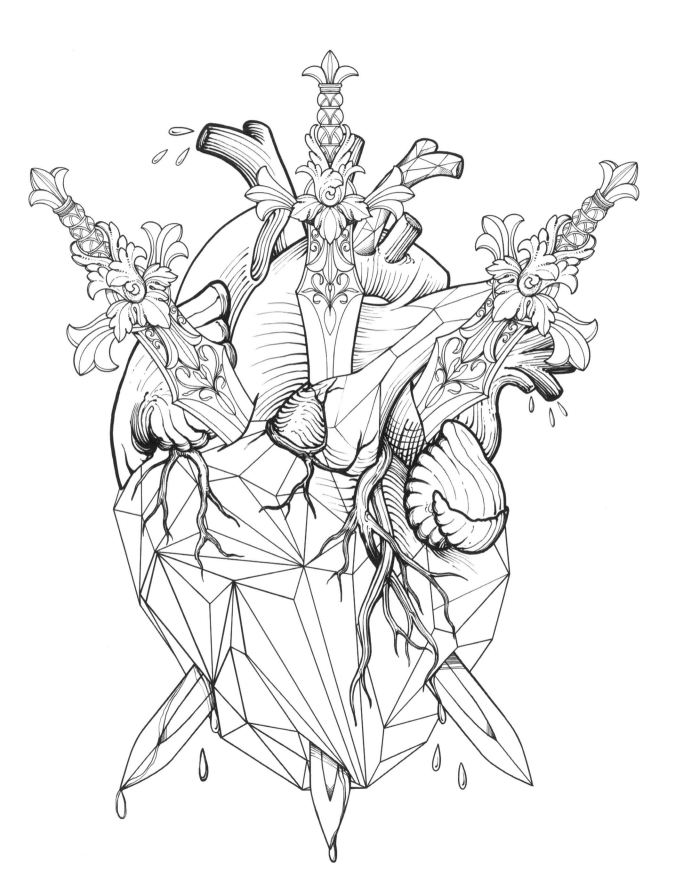

BLACKWORK

TREE OF LIFE Representing balance and harmony, this symbol is at the heart of Celtic culture. The phenomenon of rebirth is associated with Celtic trees, as well as the link between heaven and Earth—the branches reaching upward and the roots anchoring the tree into the ground. The Celtic knots that form the roots of the tree are without beginning or end, symbolizing the timelessness of nature. These are entwined with the tree's branches to frame the design. Birds-of-paradise are thought to descend from heaven and never land on Earth, and are often chosen as a decorative addition due to their elegant shape.

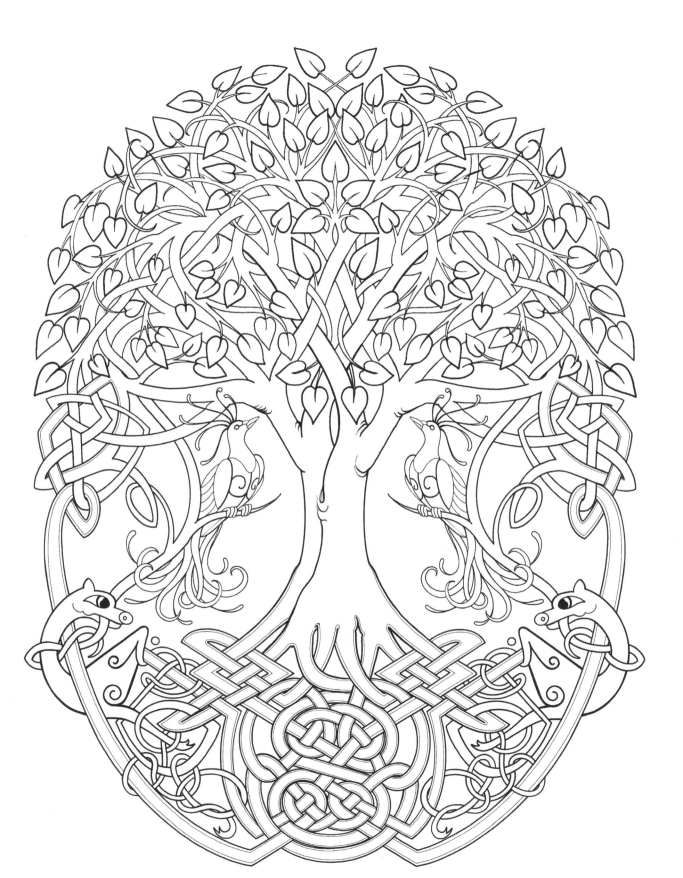

BLACKWORK

FLOATING FEATHERS

Tribal feather designs have links to many
different cultures, such as Polynesian, Celtic,
Hawaiian, and Egyptian. This "floating"
design has been chosen to signify freedom
and creativity. The addition of birds flocking
from one of the feathers takes this symbolism
one step further, representing the idea of
breaking free from constraints, of literally
"flying free." The birds look striking when
colored as silhouettes, entirely in black.

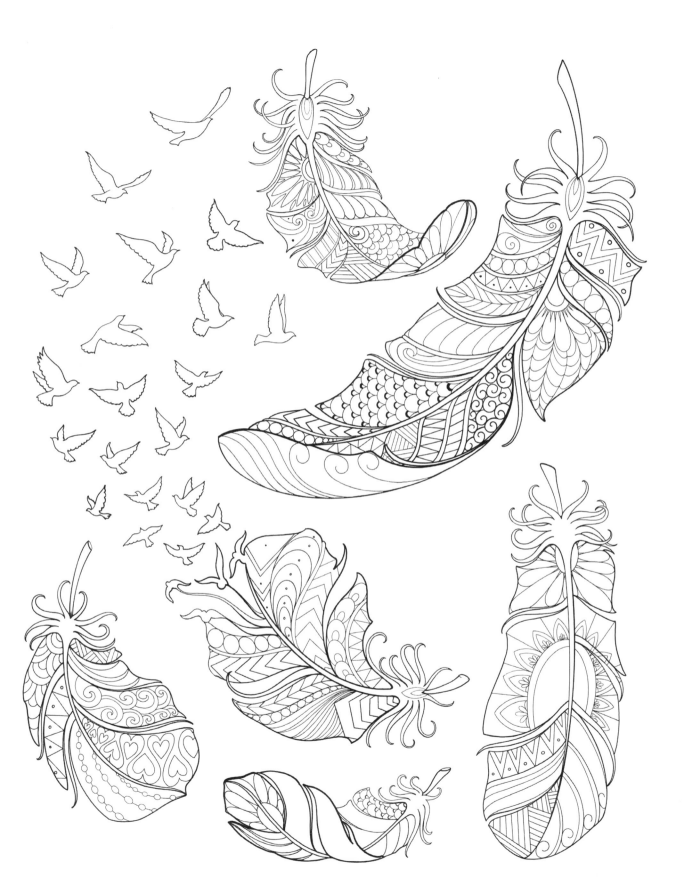

NEO-TRADITIONAL

A celebration of traditional tattoo style but with a modern, updated aesthetic, neo-traditional includes a more varied color palette than its Americana counterpart, blending jewel tones, such as blues and greens, in soft gradient.

Neo-traditional does borrow some techniques from the Americana style, such as strong black outlines, but a more diverse range of imagery makes it a popular contemporary choice. Calling on art movements such as Art Nouveau, Art Deco, and Japonisme for inspiration helps the neo-traditional style achieve a richly extravagant look. Common subjects are flowers, portraits of women, skulls, eyes, and diamonds, as well as animals, such as owls, lions, and wolves.

ROBED SKULL Skulls are one of the most enduring motifs of the neo-traditional style. Representing mortality, they can be used in a motivational sense, as a reminder to enjoy life before death finds us. The flowers depicted here continue on the same theme—roses are traditionally associated with funerals, particularly those in pale pink, which are a symbol of appreciation and admiration.

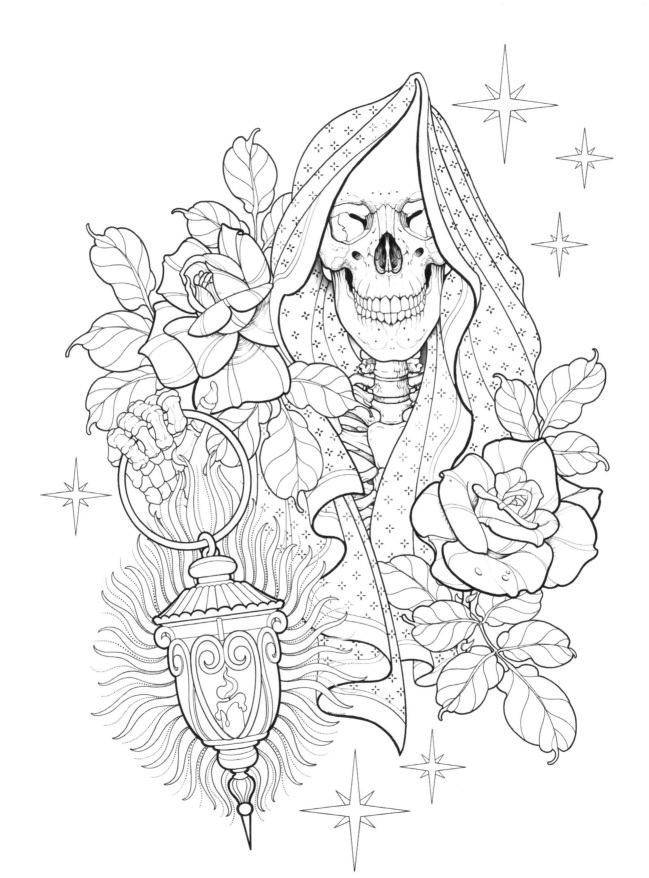

NEO-TRADITIONAL

WONDERLAND The story of *Alice's Adventures in Wonderland* remains a source of fascination to many, thanks to its spellbinding combination of mathematic principles and powerful symbolism. This Wonderland-themed tattoo is a great example of the neo style, combining classic tattoo elements, such as flowers, with Wonderland motifs, such as a looking glass, Cheshire cat, miniature bottle, and tea-party fare. A Wonderland design celebrates the bizarre and eccentric, and the joy to be found in seeing the world differently from everyone else.

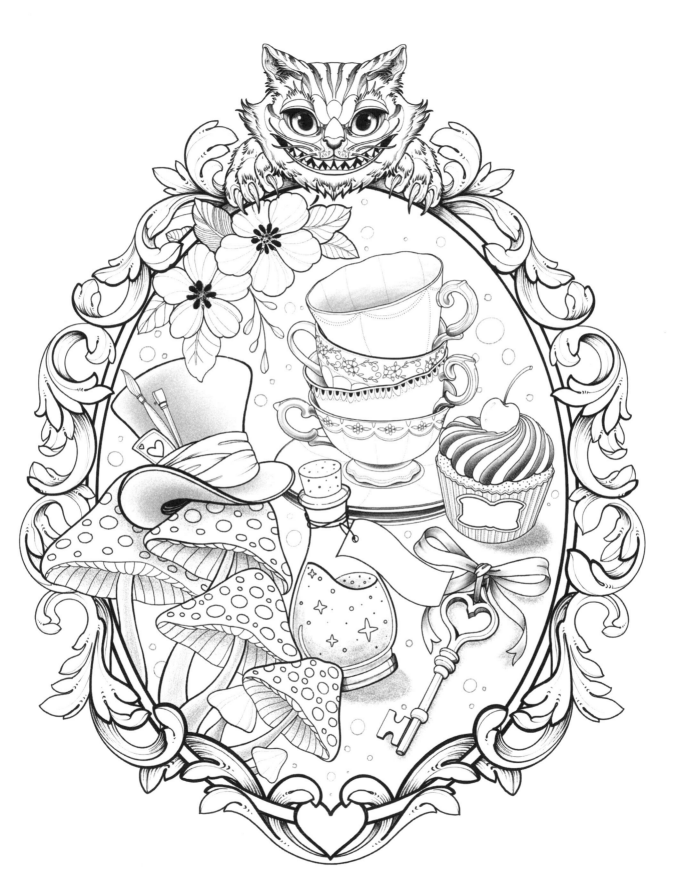

NEO-TRADITIONAL

W O L F Symbolizing power, loyalty, and valor, a design featuring this pack animal is a popular choice for anyone wishing to celebrate strong bonds with family and friends. Here, the wolf is depicted snarling, which, accompanied by the decorative arrows, adds to the overall ferocity of the image. This design might be seen on someone who wants it to be known that they are willing to do whatever it takes to defend their "pack."

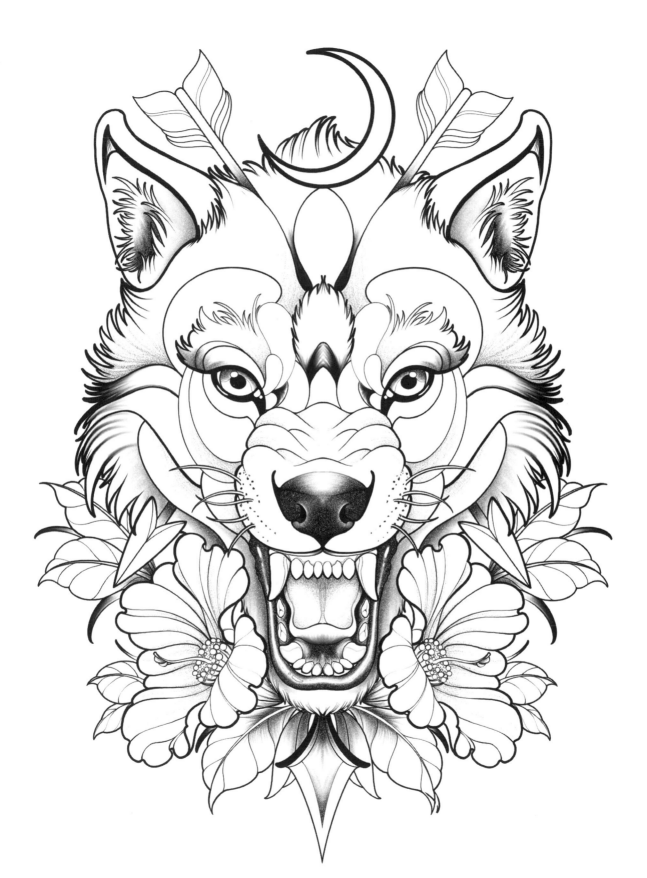

NEO-TRADITIONAL

ART DECO PEACOCK

Resplendent in jewels, this noble peacock celebrates the luxurious side of life with its grandeur and beauty. Like the roses beneath it, the peacock signifies pure, true love, as well as immortality. The combination makes this design the perfect vehicle for the rich colors that are a common feature of the neo-traditional style.

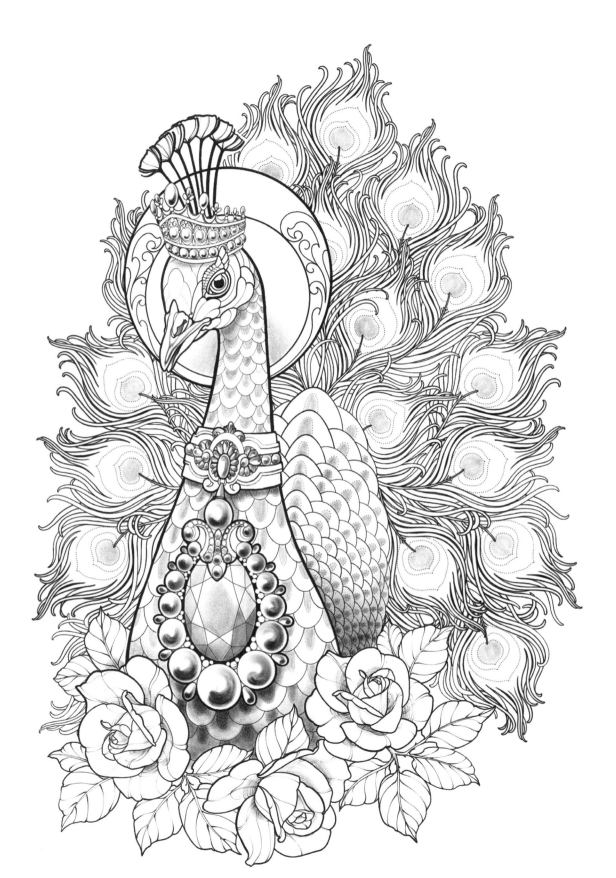

NEO-TRADITIONAL

A R M O R Among many strongly
positive connotations, a knight's armor
tattoo evokes loyalty and heroism.
Exemplifying bravery, a knight would
be taught to fear nothing, and fight
to the death for their lord or king. As
such, someone choosing this design
can display their commitment
to making any sacrifice necessary
for their honor. Armor tattoos are
usually highly decorative, adorned
with rich, intricate patterning.

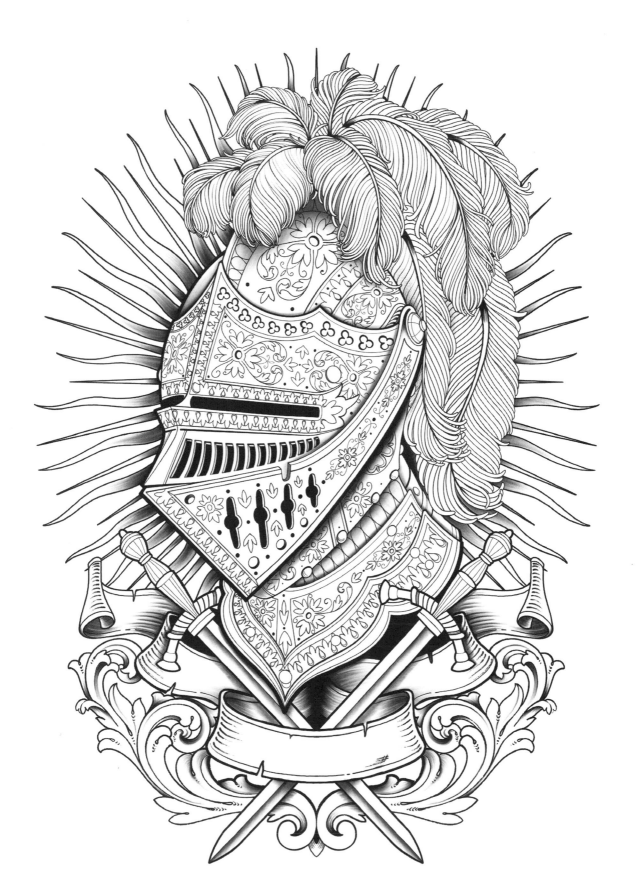

STEAMPUNK

Although steampunk has been around for several decades, it is still considered a relative newcomer when compared with other, more traditional tattoo styles. Steampunk tattoos generally combine futuristic elements, inspired by science fiction or fantasy, with a nineteenth-century aesthetic, and utilize bold outlines with a colorful fill.

Many designs are based around metal and machinery, and sometimes use these features to create optical illusions. Some technically difficult inkjobs make it look like there are gears glimpsed beneath the skin.

AIRSHIP Looking very much like a dream machine from a science-fiction novel, this hot-air-balloon-cum-airship carries all of the trademarks of the steampunk style. From the retro swags and embellishments on the balloon itself to the cogs and gears of the "ship" below, there is no doubt that this design could have stepped straight from the pages of an adventure story.

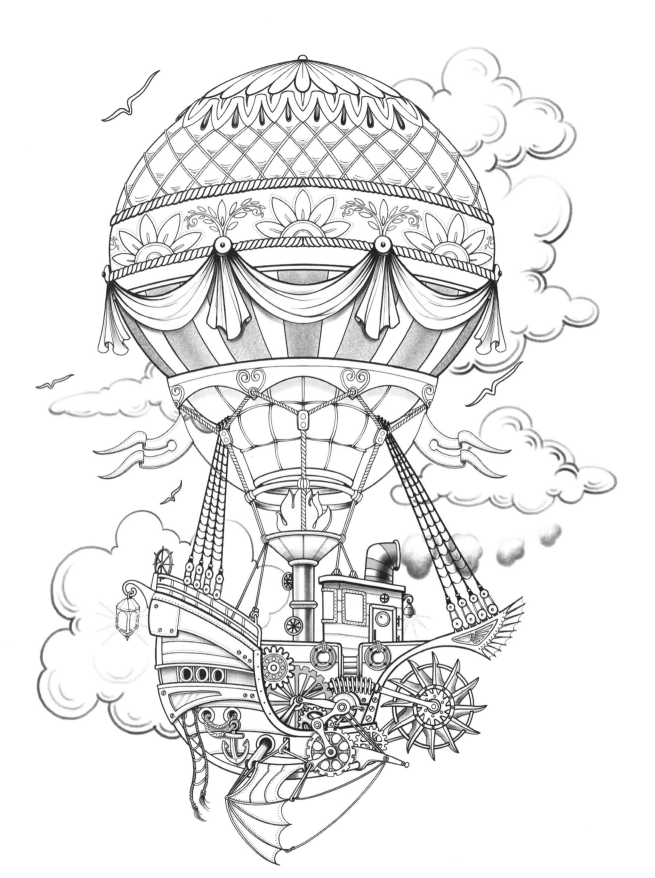

STEAMPUNK

O W L In true steampunk style, the biomechanical owl takes on an elaborate, sophisticated design inspired by robotics and machinery. Throughout history, owls have been associated with wisdom, the moon, witchcraft, and being able to see a truth that may elude others. They are mysterious nocturnal creatures and have inspired both awe and fear in people. In many cultures, owls symbolize change, transformation, and magic. As such, an owl tattoo can represent vision and hope for the future.

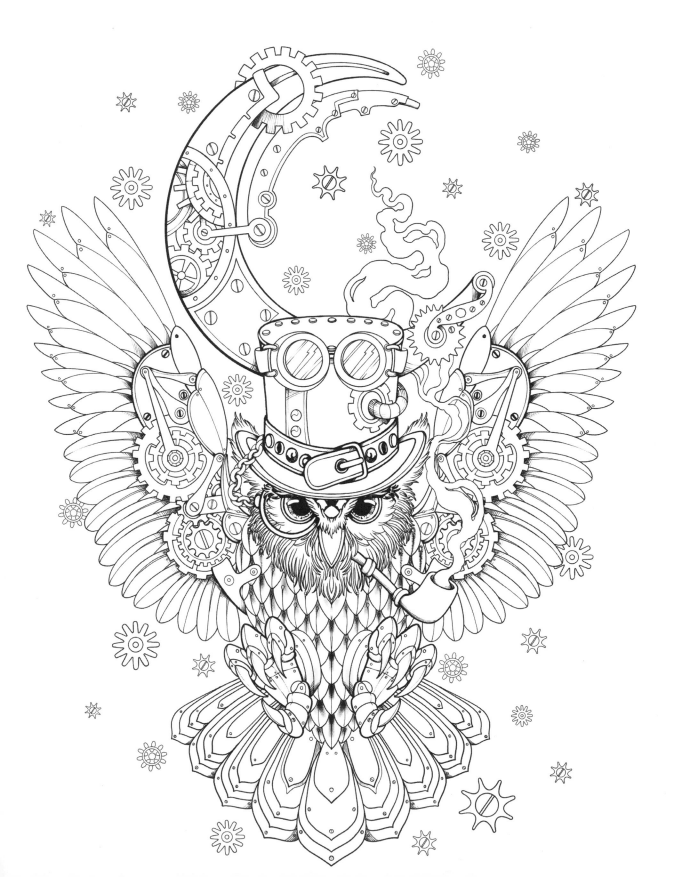

STEAMPUNK

B E E The bee is essential for maintaining life, and a bee tattoo may be seen as a symbol of fertility, connection, and living in harmony with nature. As bees work together for the benefit of the hive, they are also associated with loyalty and determination, and can be seen as a sign of a sweet, productive life.

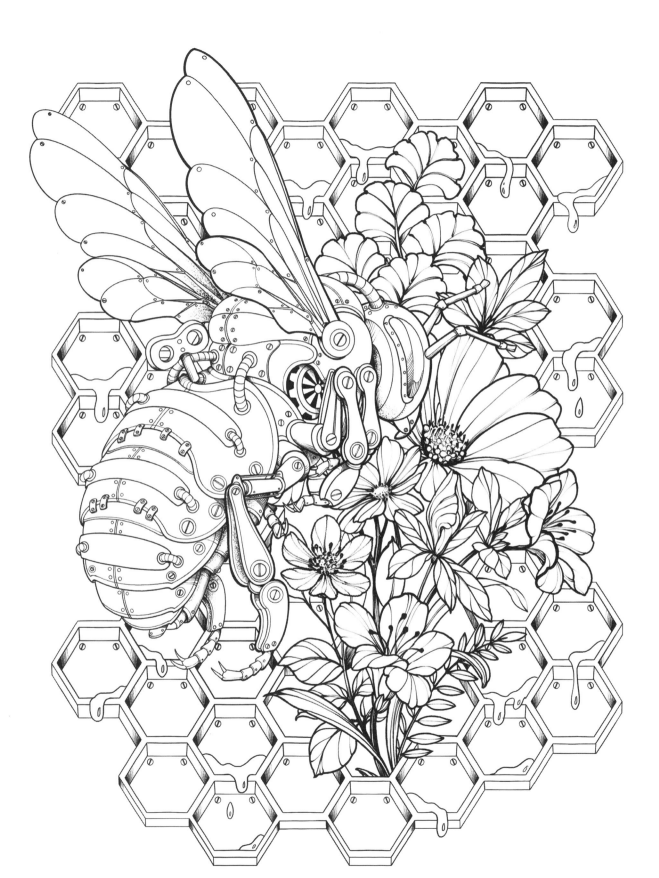

STEAMPUNK

E L E P H A N T The intricate, retro style of a steampunk tattoo is particularly effective when used for animals, revealing the beauty of the natural form. Traditionally, an elephant tattoo symbolizes wisdom, strength, loyalty, and the ability to carry great weight with dignity and strength.

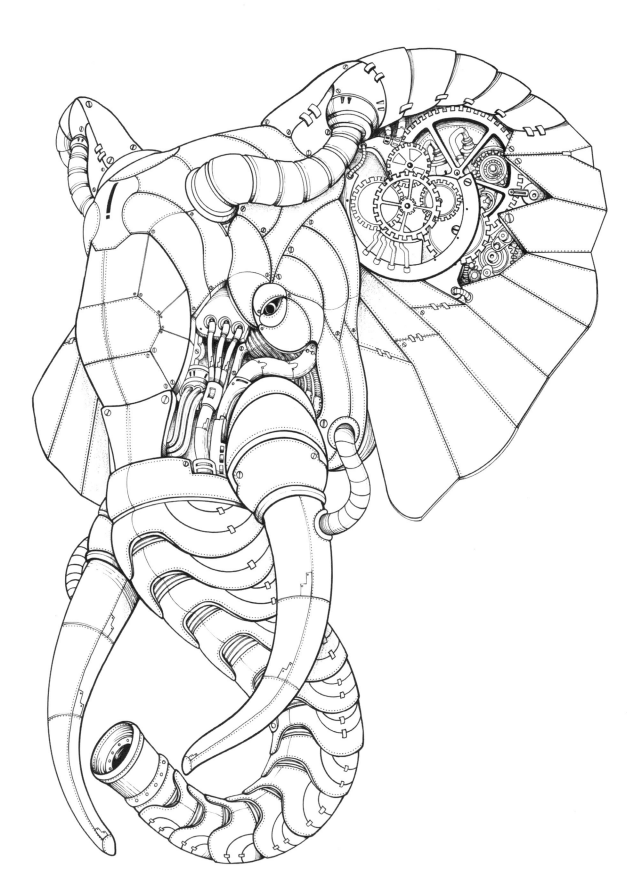

STEAMPUNK

IN COSTUME This design
is one of contrasts, reminding us not to
judge a book by its cover. The woman's
decorative collar and frills are juxtaposed
with industrial cogwheel accessories.
Likewise, her spectacles imply
a studious nature, yet the mask and
imitation gun hint at an adventurous,
take-no-prisoners persona. Someone
who chooses this design might be
keen to point out that there is more
to them than meets the eye.

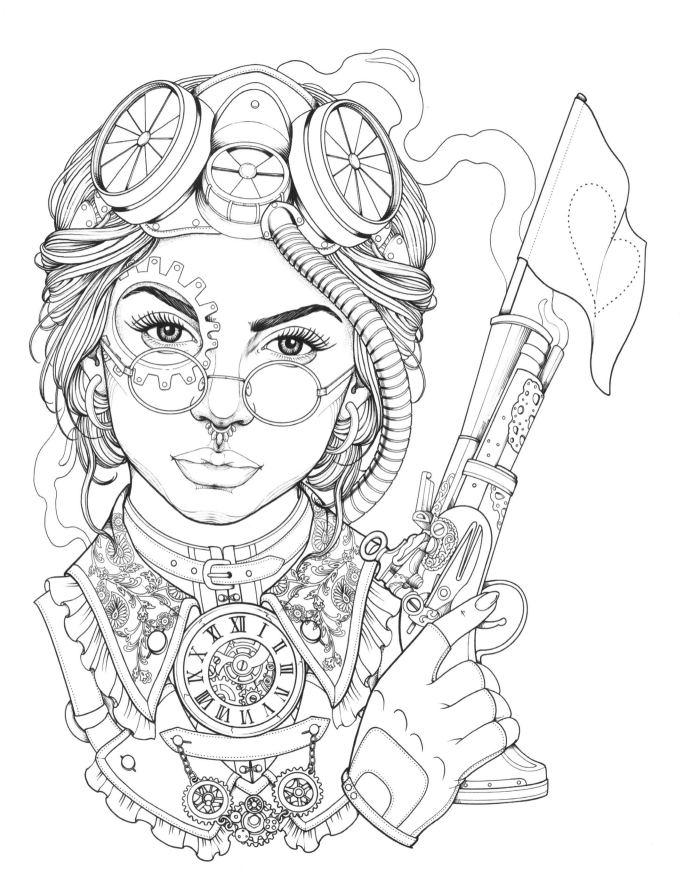

SURREALISM

One of the most creative genres of tattoo art, the origins of the surrealism style lie in 1920s France and the work of artists such as Salvador Dalí and René Magritte. With an emphasis on combining hyperrealistic images with abstract subjects, tattoo artists use fantastical and dreamlike imagery to portray a scene in which something appears to be "not quite right." Juxtaposing elements that don't logically seem to fit together opens the door to a world in which the subconscious is king and imagination can take you anywhere.

SKELETON CASTLE

A turreted castle can give any tattoo a fairy-tale quality, but here it's given a sinister edge as it emerges from within the depths of a skeleton. The pretty, fluttering flags and spiral-topped turrets are dreamlike, and in stark contrast to the horror of the openmouthed skull, giving the design a nightmarish quality.

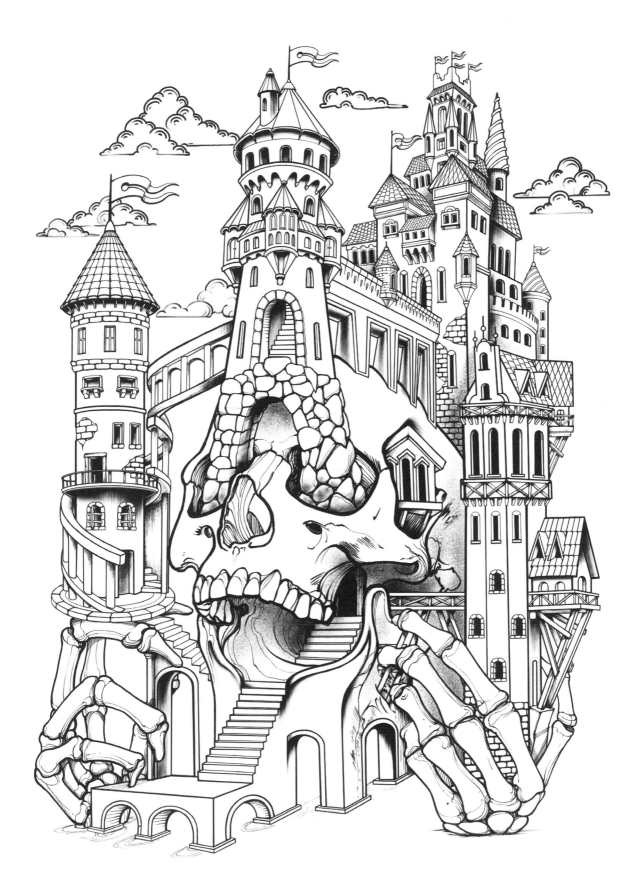

SURREALISM

CRYSTAL SNAIL

Slow and steady, the snail is most commonly used as a symbol of persistence, patience, and progress. Featuring one of the oldest symbols of human life, the spiral, the shell motif is well suited to the surrealism style as it is thought to represent inner consciousness.

Combined with the many natural elements on its back, in this design the snail represents the gradual movement toward a higher state of consciousness, with respect paid to the cyclical nature of life.

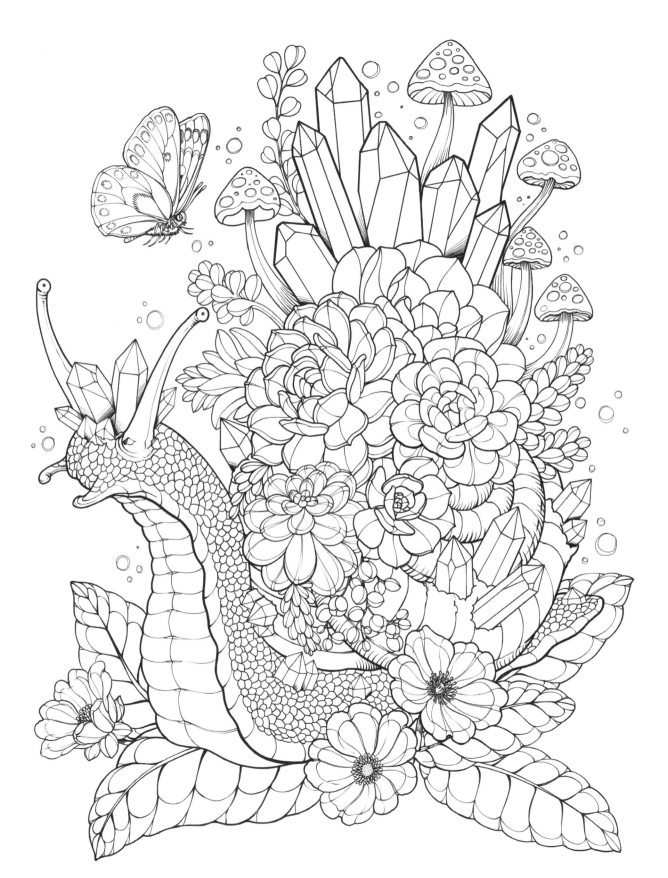

SURREALISM

UNIVERSE IN AN HOURGLASS

Containing the cosmos within an hourglass is an epic idea, especially when combined with earthly elements, as in this design. The astronaut, as an intrepid explorer, represents the human desire to give order and meaning to life. The sun, sea, and forest act as a contrast, showing there is no such struggle within nature as time marches on, and earthly elements simply exist as they are. This design reminds us not to resist the chaos of the universe.

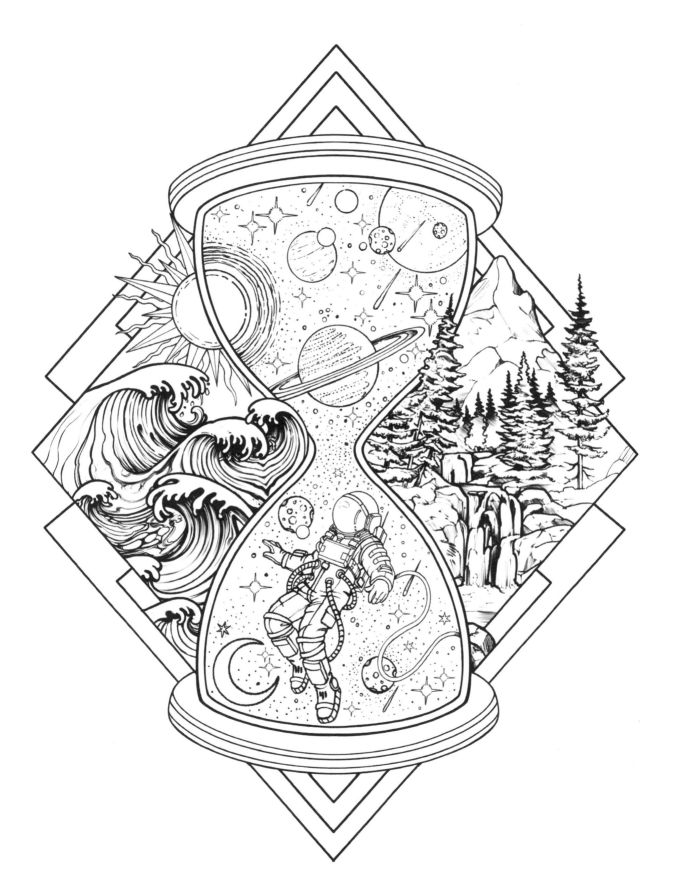

SURREALISM

MIND-BENDING VASE

The staircase that decorates this classically shaped vase, apparently leading nowhere, represents the inevitability of life's cycle, and combined with flowers on the point of wilting alludes to the transient nature of life itself. This theme is supported by the flute-shaped morning glory flowers that creep down the vase, known to bloom in the morning and close at night.

The insects, while sinister at first glance, provide a hopeful element to the design, offering the promise of life even as the blooms droop.

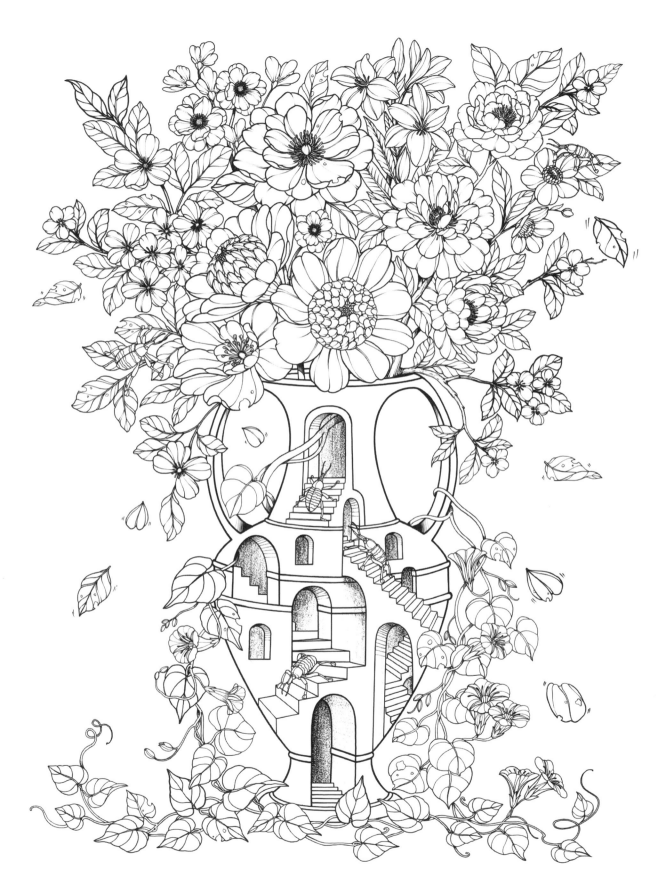

SURREALISM

OTHERWORLDLY BIRDS In this truly surreal design, the many eyes hidden in the center of the flowers invite you to look closely and perceive these hybrid creatures in their many guises. With every glance they can be transformed—from artists to observers, inanimate shapes to living beings. As with many things in life, they are beyond comprehension, and a design of this type celebrates the freedom that can be found in embracing the unusual without the need for judgment or desire to classify.

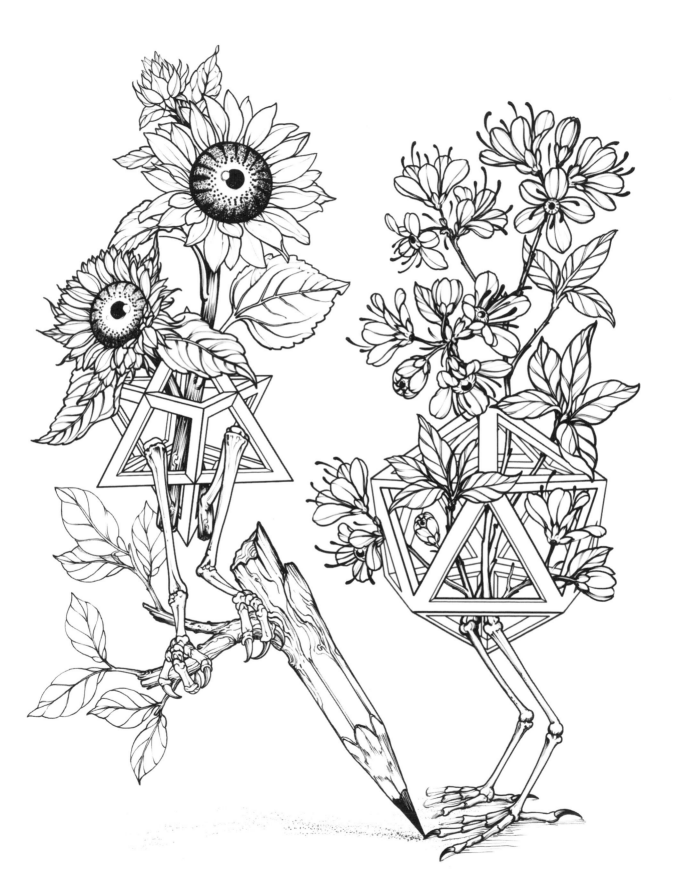

SURREALISM

BUTTERFLY WOMAN

One of Salvador Dalí's favorite subjects, butterflies are used here to represent freedom from the constraints of the conscious mind. In combination with the figure's somewhat old-fashioned dress, a person with this tattoo may be making a statement about breaking free from the shackles of traditional femininity in order to embrace a more progressive lifestyle.

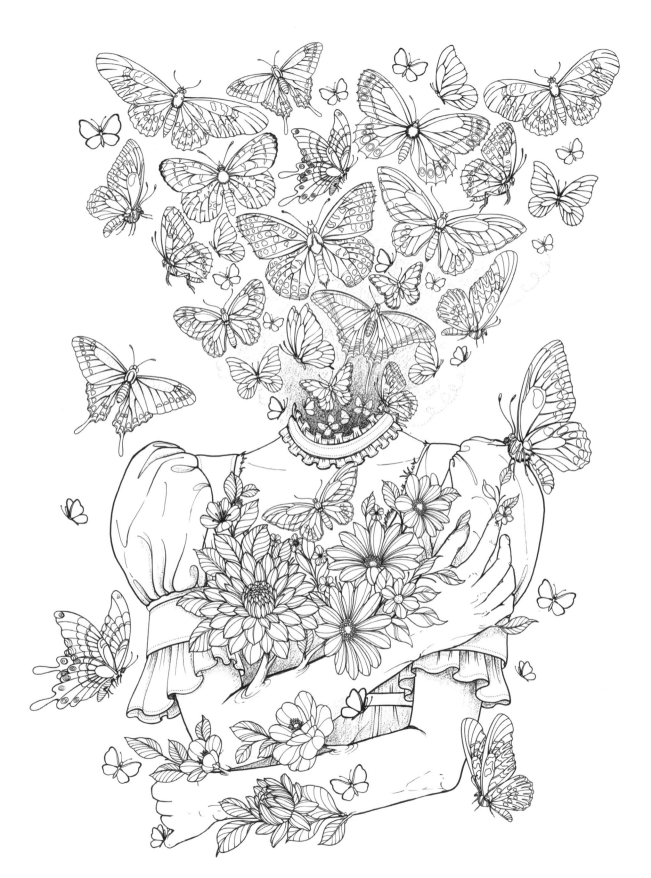

JAPANESE

Japanese tattoos are expressive and bold, one of the reasons they've long been popular around the world. The vibrant colors and creative shading make these inkings eye-catching and exciting. The imagery used is often a way to honor folklore or tradition, and common designs include mythical beings, such as dragons and phoenixes and the supernatural, mixed with flora and fauna.

The most traditional Japanese tattoos are referred to as "Irezumi." This is an ancient tattooing style, rich in symbolism. Common motifs include koi fish, dragons, geishas, cranes, and flowers. Use of color is very important, with different shades and combinations carrying their own meanings.

HAND FAN The fan itself is a symbol of prosperity, spreading out when opened like a blooming flower or the expansion of wealth. The design inside echoes the themes of generosity and good fortune, featuring a crane, which is known as the "bird of good fortune." Cherry blossoms, which have a season of only two weeks, are often used as a symbol of the transience of life or encouragement to enjoy life's pleasures while you can.

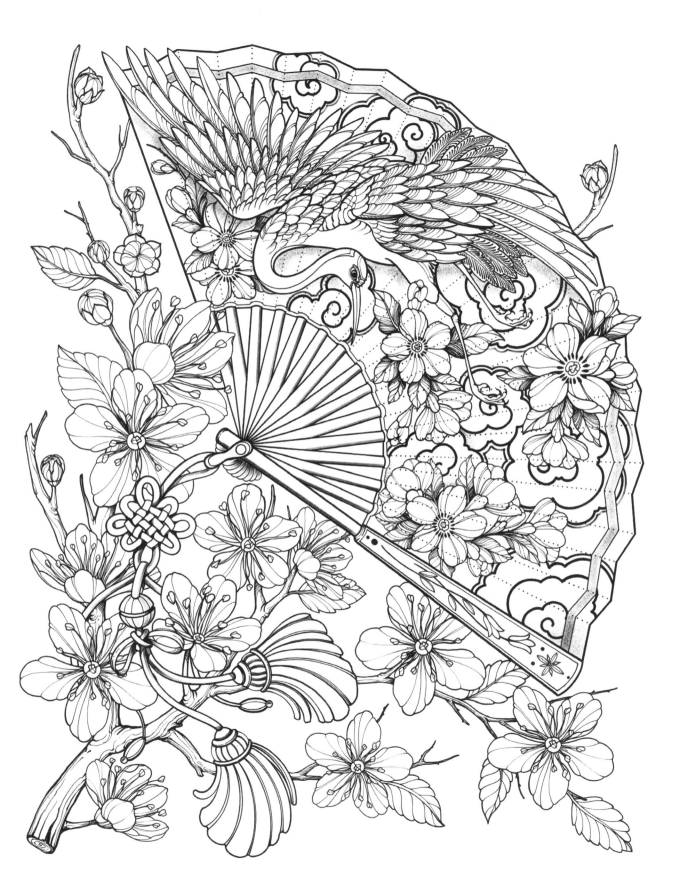

JAPANESE

K O I A koi carp design represents strength, accomplishment, success, determination, and good luck. This is one of the most popular images in Japanese body art because of the carp's perennial importance and symbolism. The meaning can be altered depending on color choice—for example, red represents love, power, and motherhood, while black is associated with adversity and a struggle to succeed. The lotus flower, too, represents perseverance, as this beautiful flower grows in muddy waters.

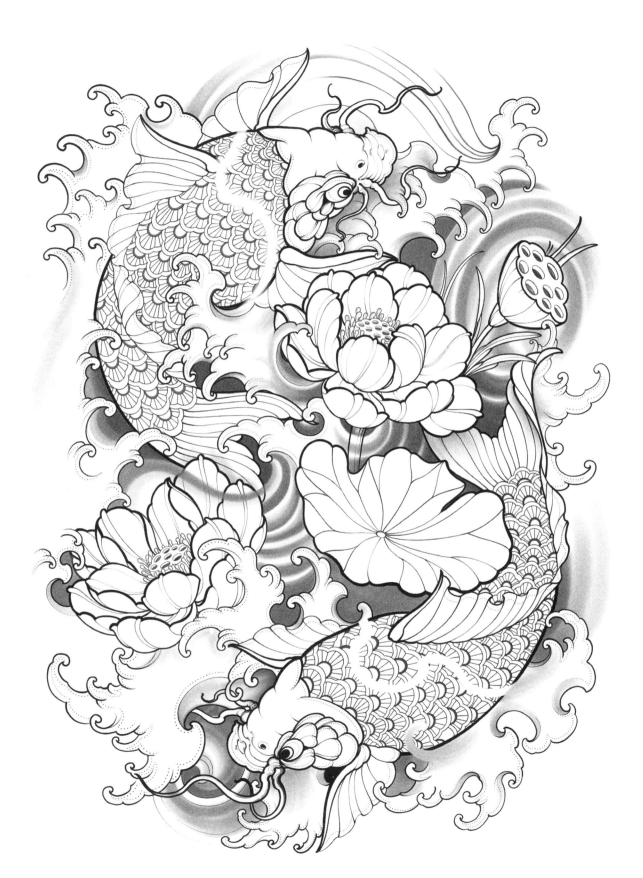

JAPANESE

HANNYA MASK It would be easy to assume such a fearsome-looking character is meant to be intimidating, but the hannya has been an important symbol of luck and prosperity in Japanese culture for centuries. Thought to provide protection against history repeating itself, a design of this type could be used as a reminder to leave the past behind and to keep moving forward. The colors of the mask can affect its meaning—the darker the palette, the more tumultuous the experience to overcome.

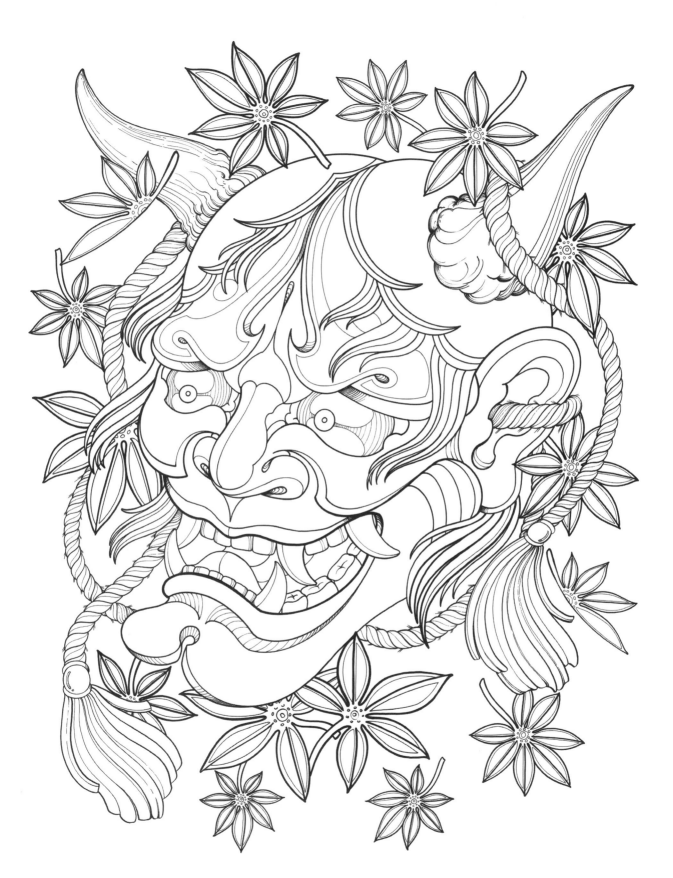

JAPANESE

TIGER AND SNAKE

Symbolic of a struggle to overcome toxic habits or influences, this design depicts two fearsome creatures—a tiger, representing bravery, and a snake, symbolizing temptation—embroiled in a fierce fight. The warm, nurturing presence of the sun, a symbol of new beginnings, indicates that a fresh start is on the horizon and is a sign that good can prevail over evil.

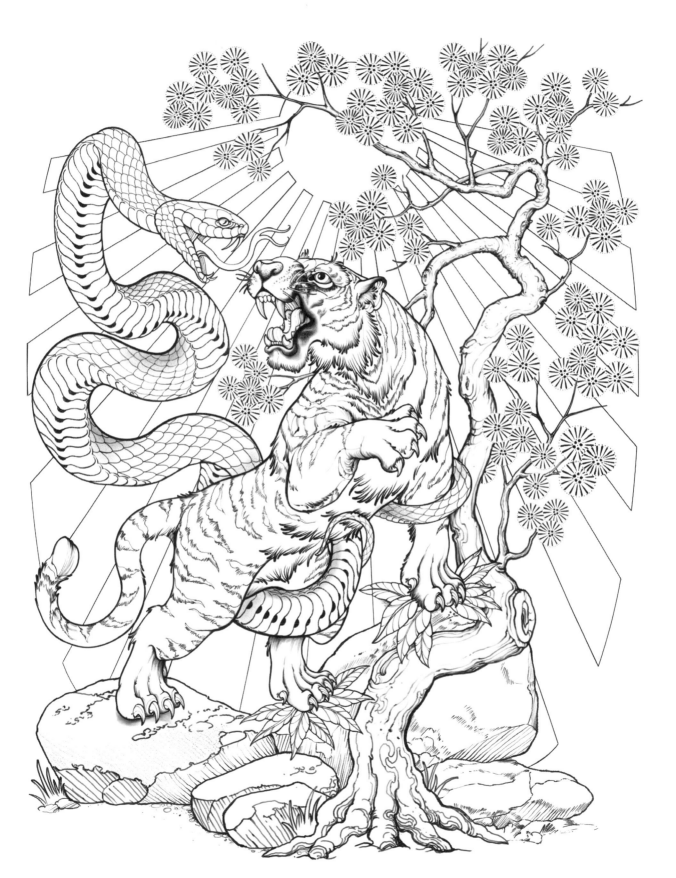

JAPANESE

JAPANESE DRAGON

As an important symbol in East Asian mythology, the dragon is the most popular Japanese tattoo design. Dragons are seen as protectors of mankind, symbolizing power, resilience, wisdom, strength, and a force for good. Dragon tattoos vary in design, using elements from a range of animals and mythical creatures for dramatic or symbolic effect. Japanese dragons are traditionally depicted with three toes and may feature the body of a snake and the claws of an eagle, depending on the style.

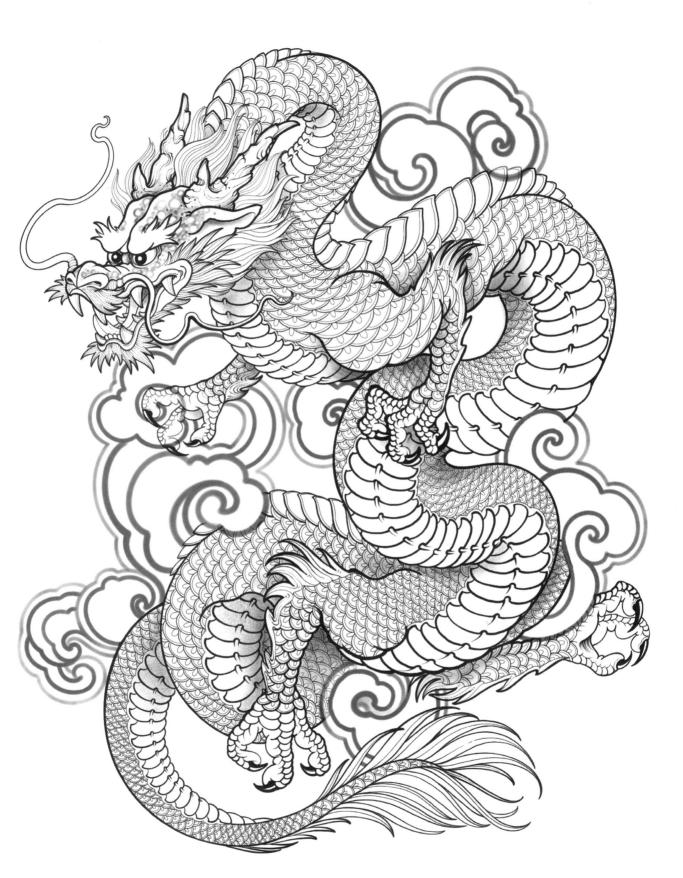

SKETCH

Sketch tattoos involve crosshatching, incomplete strokes, and elements that do not fully close, looking as if the artist has sketched them onto the skin. The shading work is bold and rough, and may appeal to people who love the dynamic quality of a work in progress, rather than a polished end result. The "sketchy" line style can evoke a feeling of movement and complexity.

Often designed to look like an artist's preliminary drawings, common subjects in this style include portraits, nature designs, or even abstract motifs.

AFRICAN QUEEN

Tattoos of African queens can be very empowering, representing resilience and strength. A tattoo of this nature is also a way to honor women in general. This design emphasizes the beauty and authority of this queen—the precious adornments are indicative of her wealth and power.

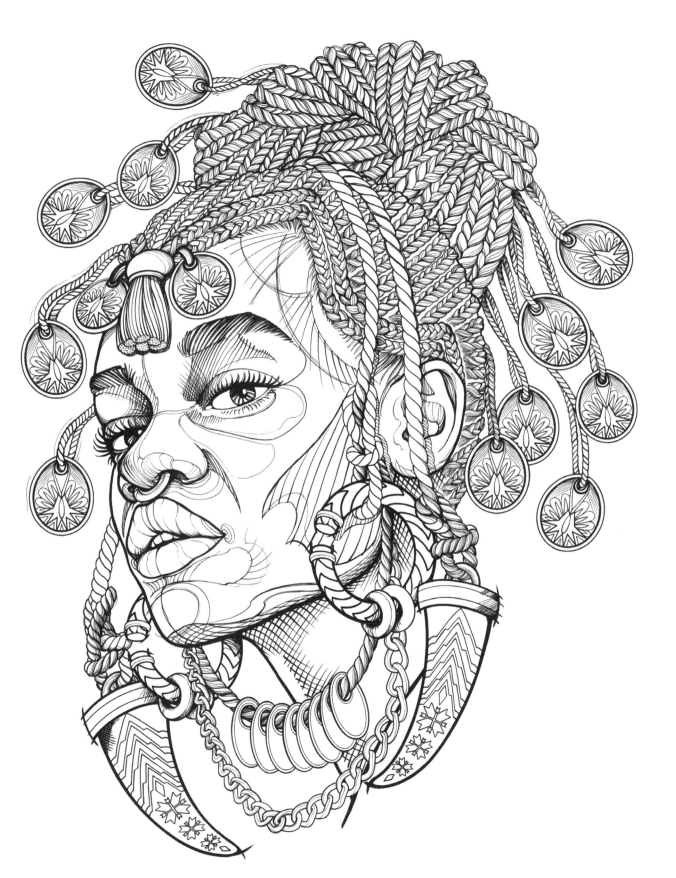

SKETCH

TREE HOUSE A symbol of escapism and childhood adventure, a tree house tattoo signifies a desire to return to an innocent and simple way of life. In the sketch style, this tree house has the feeling of an architect's drawing or blueprint, emphasizing the idea of a plan for the future coming to fruition. The addition of a mole in human clothing brings a further fantastical, playful element to the design.

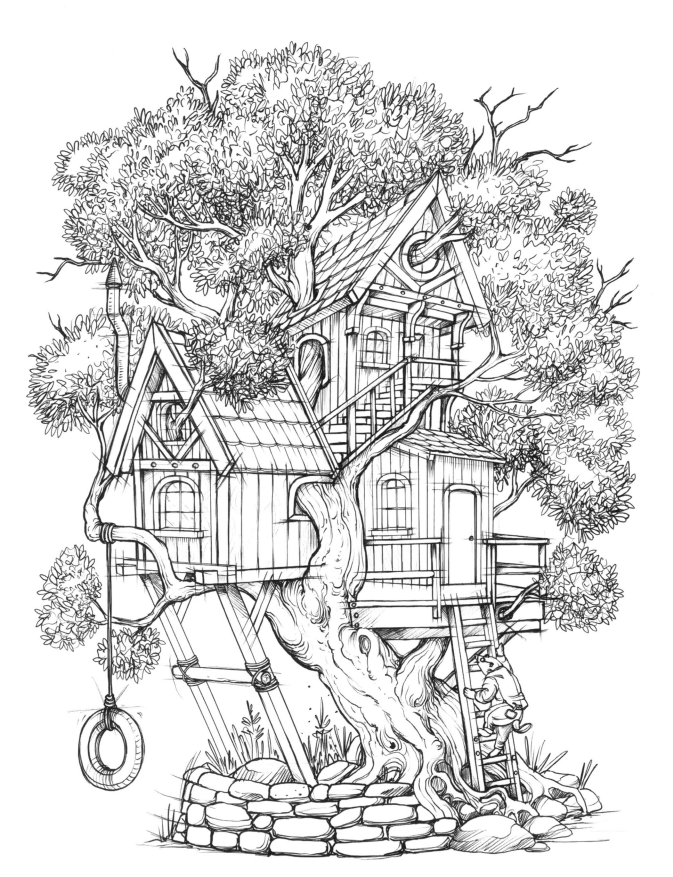

SKETCH

TAROT CARDS As every tarot card holds a unique meaning, tarot card tattoos can take many forms and mean something different to everyone. Motifs commonly seen in tarot decks are perfectly suited to the hand-drawn sketch style, and animals, nature, and portraits appear full of life. The most popular tarot cards incorporated into tattoo designs include The Magician, symbolizing overcoming obstacles, and The Sun, which represents light, joy, and celebration.

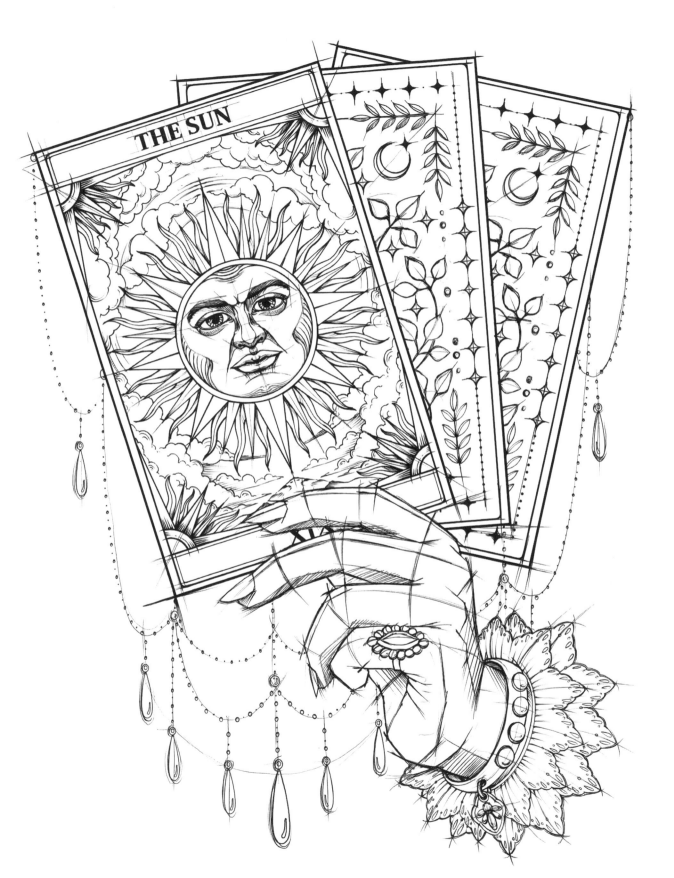

SKETCH

EAGLE MAN Evoking a
strong, masculine energy, the focus of this
design is the bird, its open beak giving it a
dynamic energy in comparison to the wise,
contemplative expression of the man. The
eagle, apparently the victim of a hunter,
is nevertheless alive, demonstrating an
ability to survive against the odds. This
links to the traditional view of the eagle
as a bold and fearless independent spirit.

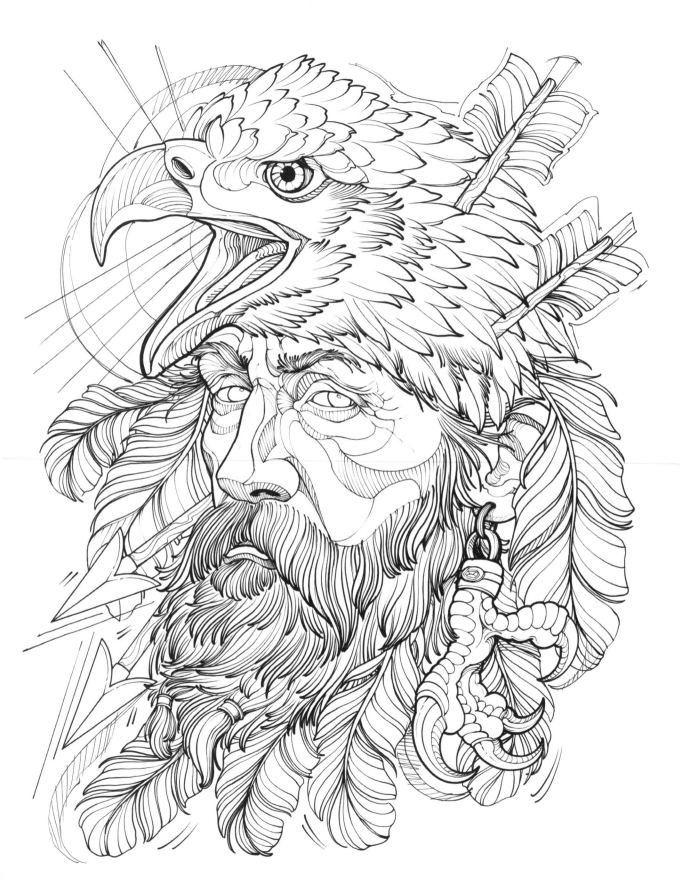

SKETCH

FAIRY Traditionally, fairies are used to represent feminine energy and a free spirit. Many mythologies have their own version of the fairy figure, symbolizing a mystical, magical world.

With her elaborate wings, this fairy is depicted as a cross between an angel and a beautiful butterfly, inviting the use of bright colors and intricate patterns. Choosing the sketch style for this design enhances the delicacy of the artwork and adds to the magical, whimsical feel of the piece.

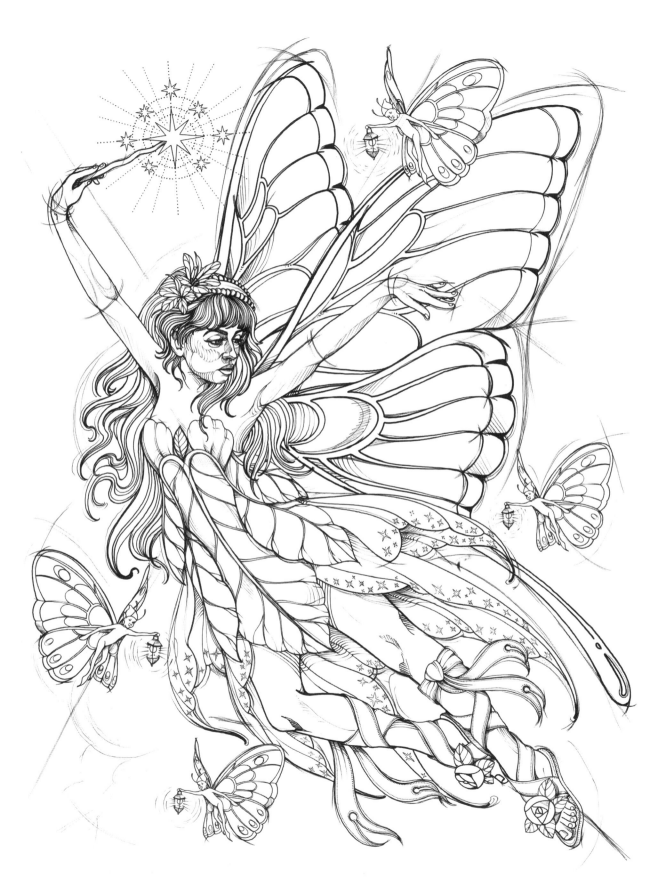